EUGÈNE-LOUIS CHARVOT

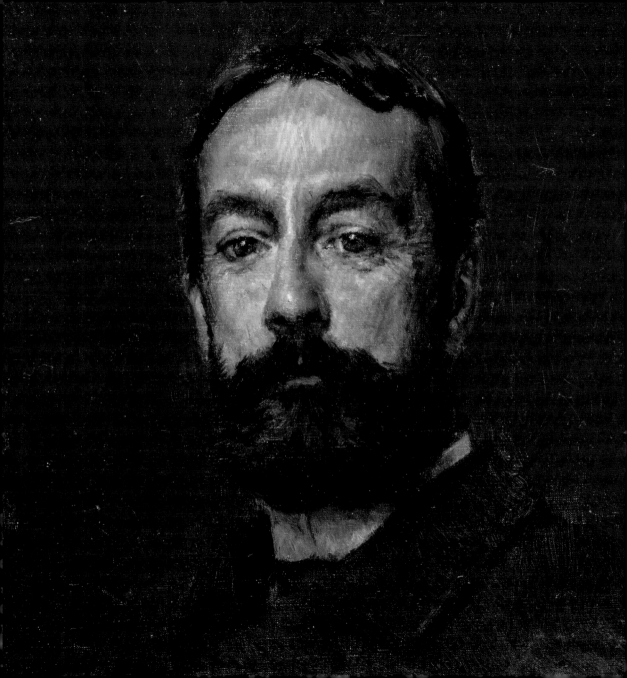

EUGÈNE-LOUIS

CHARVOT

Susan M. Gallo

Cummer Museum of Art & Gardens, Jacksonville, Florida, in association with D Giles Limited

Eugène-Louis Charvot is supported in part
by the family of Dr. Eugène-Louis Charvot:
Olive M. Bryan, William Gordon and Sahoko
Tamagawa, Carol and Harry Pozycki, and
Claudia and Dan Sayre

Cummer Museum of Art & Gardens
expresses gratitude for the operating
support provided by the Morton R.
Hirschberg Bequest.

This catalogue accompanies the exhibition
Eugène-Louis Charvot on display at the
Cummer Museum of Art & Gardens,
February 11–December 13, 2020.

The exhibition was curated by
Susan M. Gallo.

© 2019 Cummer Museum of Art & Gardens

First published jointly in 2019 by GILES
An imprint of D Giles Limited
66 High Street,
Lewes, BN7 1XG, UK
gilesltd.com

ISBN: 978-1-911282-44-0
(softcover edition)

For Cummer Museum of Art & Gardens:
Project Manager: Kristen Zimmerman, Registrar
Managing Editor: Holly Keris, Chief Curator
Retail Coordinator: Susan Tudor, Manager
and Store Buyer

For D Giles Limited:
Copy-edited and proofread by Sarah Kane

Designed by Alfonso Iacurci
Produced by GILES, an imprint of
D Giles Limited
Printed and bound in China

All measurements are in inches
height precedes width.

Front cover:
Eugène-Louis Charvot (1847–1924)
La rue El-Halfaouine à Tunis (El-Halfaouine
Street, Tunis), 1889
Oil on canvas
47 ¼ × 39 ⅞ in.
Gift of Yvonne Charvot Barnett in memory
of her father Eugène-Louis Charvot
AG.1999.5.3 (Plate 8)

Back cover:
Dr. Charvot Working at an Easel in a Field,
before 1892
Photograph
6 ½ × 9 in.
Charvot Family Archives

Frontispiece:
Paul Jean Marie Sain (1853–1908)
Portrait of Eugène-Louis Charvot, c. 1896
Oil on canvas
16 ¼ × 13 in.
Gift of Yvonne Charvot Barnett in memory
of her father Eugène-Louis Charvot
AG.1999.5.18

CONTENTS

FOREWORD

We live at an exciting moment in art history. With the postmodern turn beginning in the 1960s, and then the ascent of post-colonialism from the 1980s until its apogee today, scholars have been liberated to critically assess "the canon" – that is, the roster of artists whose work is of sufficient quality to merit recognition. Art historians of all periods have "rediscovered" artists lacking from that canon, some of whom have been hiding in plain sight. The reasons that artists have been forgotten to history are many. In some cases, systemic inequities related to ethnicity or gender have suppressed broader recognition; in others, artists toiled valiantly but did so outside of major markets and thus access to traditional marketing and promotional networks; and sometimes, luck was simply not on their side. But the arc of history is long, and museums, as arbiters of the canon, seek out quality and celebrate artistic merit when presented with it.

It is for these reasons that I am delighted to publish this catalogue of the work of Eugène-Louis Charvot. Charvot is one of those artists whose work was forgotten, perhaps because he does not fit neatly into the standard art historical narrative. Our model of history celebrates categories, and our bias is to neatly segment history into periods and artists into styles. Eugène-Louis Charvot complicates these boundaries since he spans them, but in so doing he gives us a truer and fuller sense of late nineteenth- and early twentieth-century artistic production.

A Salon medal winner, he had a penchant for realism in his favored genre, landscape, and yet he defined landscape liberally, to include streetscapes.

He painted in North Africa but he did so with an anthropologist's, not a voyeurist's, eye. He appreciated color, his paint is applied loosely and energetically, and he was even influenced by Symbolist painting, but one could hardly call him a post-Impressionist. Consider his canvas *La rue El-Halfaouine à Tunis*. The white mosque stands in stark contrast to the luminous sky; the figures are at once sensitively treated and sketchily modeled; and the scene is full not of exaggerated action but of quiet and calm.

Charvot lived at a time of dramatic change – one of rapid industrialization and a concomitant loss of the landscapes in which he grew up; one characterized by the peak of colonialism, in which he participated as a doctor; and one of great uncertainty as mercantilism began to give way to capitalism and a new world order – and his work captures these tensions.

However one characterizes Charvot's work, his vibrant paintings and subtle etchings suggest a comfort with his subject matter and a command of his media that differentiate him. Charvot may never sit alongside Bouguereau, Monet, or Gérôme, but through the generosity of his daughter, Yvonne Charvot Barnett, and this catalogue, we hope to expand the canon and reintroduce his work into the discourse of fin-de-siècle European material culture.

Adam Levine
George W. and Kathleen I. Gibbs Director and CEO,
Cummer Museum of Art & Gardens

ACKNOWLEDGMENTS

Many people have supported and assisted me in the rediscovery of Eugène-Louis Charvot, and I would like to acknowledge and thank the following:

Yvonne Charvot Barnett, for championing her father's work and for graciously meeting with me to share memories of her father; Yvonne's neighbors and family in France for helping to preserve Dr. Charvot's artwork and belongings, which might otherwise have been destroyed during World War II; Claudia Barnett Gordon and William Stanly Gordon for organizing and cataloging family artwork and papers into a chronology of Eugène Charvot's life, which was the foundation for my research. Claudia also collaborated with me to discover long-forgotten family letters and photographs, and it was a joy to work with her; Yvonne Barnett West and Caroline Barnett Bryan for their early memories of France, their sharing of family lore and their devotion to the beauty of art; Claudia Gordon Sayre and Daniel Russell Sayre, William Gordon and Sahoko Tamagawa for their trust in allowing me open access and multiple visits to the Charvot Family Archives, and for their gracious hospitality and friendship along the way; Olive M. Bryan, Caroline B. Pozycki and Harry S. Pozycki, Charles West and Cecily West for their additional support and for conversations and access to more family history; Marie José Coll for my visit with her in Paris, and who, with her daughter Sarah Frank, allowed their Charvot paintings to be included in this publication.

Directors Kahren Arbitman, Maarten van de Guchte, Hope McMath, and Adam Levine at the Cummer Museum of Art & Gardens for their encouragement and guidance; Holly Keris, Kristen Zimmerman, Mark Warren, and Brian Shrum in the Cummer's curatorial department for being the best of colleagues; former curatorial members Vance Shrum, David Tarver, and Jennifer Lisella-Marcellus, for being there at the beginning; Aaron de Groft, for his early mentoring and high standards of excellence; Nelda Damiano for working with me to define the project, guiding me through the facets of printmaking and help with translation and editing; Kathe Kasten for additional editing, review, and friendship; the members of the Cummer education department and the wonderful Cummer docent corps for bringing Charvot to life for museum visitors; Jenna Sparrow for fact-checking; The Brick Store Museum in Kennebunk, Maine for the use of their Program Center; the curatorial staff of the Musée Anne de Beaujeu in Moulins, France for confirmation of works in their collection; my family and friends, especially Joan Gallo, Mary Jane Trimble, Debbie Early, Annemarie O'Connor, Judith Leroux, Mimi Tate, Cyndi Brettman, Carol Smolenski, Penelope Pate Greene, Bill Fleury, Mary Ann Dufresne, Sr. Judith O'Connell, and Deb Studebaker, who listened and encouraged; and finally to Jim, Grace, and Ned, and now Wes, Ariel, and Evan – my heart and my joy, always.

Susan M. Gallo
Author and Guest Curator

A PASSION FOR ART

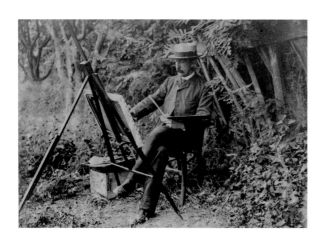

Eugène-Louis Charvot was a fascinating nineteenth-century Frenchman. A distinguished physician and surgeon, Charvot spent his professional career in the military, serving his country in the Franco-Prussian War, in colonial Tunisia and Algeria, and during World War I. As a military physician, he attained prominent leadership positions, published scientific articles in medical journals, and was awarded the medals of Chevalier and Officier de la Légion d'Honneur and the Tunisian Commandeur de l'ordre du Nicham Iftikar.[1]

Despite the rigors of his prestigious medical career, Charvot professed that his first love was art, and he developed a parallel career as an accomplished painter and etcher. He entered the Salons in Paris on a regular basis, first with paintings and later with prints, and established himself in artistic circles. In an 1885 letter he wrote, "I am extraordinarily energized to make art for others and above all for myself...I have a passion for art...an immeasurable love, one that absorbs me almost completely (Fig. 1)."[2]

Recognized in his own time but unnoticed by art historians, the rediscovery of Charvot's art and writing provides an opportunity to examine prints and paintings formerly lost to history. Additionally, his surviving letters and diaries are reflections on his art, the artistic milieu of Paris, different ways of working with oils and etching, and observations of life in French colonial North Africa. Viewed together, these documents offer a first-hand glimpse into a significant era of artistic transition and change.

Born in Moulins, France, in 1847, Charvot was the son of a headmaster and the grandson of a prominent attorney. The family lived in farm country, where Charvot would spend time in the fields and woods of Bourbon l'Archambault, a region that would consistently figure in his work. Writing of those days he said, "I had the invaluable luck of having a childhood in the country...in the fullness of nature in the midst of fields populated by animals and peasants. In school I studied the sciences, the most substantial subjects, but I never lost the desire...to also follow my artistic path, one that resulted in my becoming a landscapist."[3]

Artistic Beginnings

Charvot began his medical studies in 1866 in Strasbourg, but the Franco-Prussian War forced him to finish his medical degree in Paris, at the end of the conflict. Whether the selection of Paris was by chance or by design, Charvot used his residency in the city to further his artistic education. He became a student of Félix-Henri Giacomotti (1828–1909), a successful and respected painter of historical scenes and portraits, whose use of colors greatly impacted Charvot's works.[4] He wrote, "...you will find a palette on which I have outlined the name and place of each color (Fig. 2). It's the palette of Giacomotti, which as a faithful student, I've completely adopted."[5] Charvot also studied with Léon-Joseph-Florentin Bonnat (1833–1922), an artist and an influential Salon juror with whom he maintained a lifelong professional acquaintance.[6]

Charvot's study with these two noted teachers not only influenced the rest of his career but also underlined his serious sense of purpose, his self-identification as an artist, and intense interest in succeeding in the field. Letters to Charvot from his mother written during

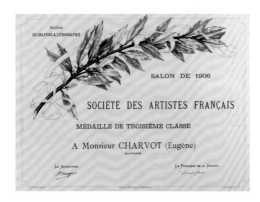

Fig. 3

Certificate, Salon de 1906,
Société des Artistes Français,
Médaille de Troisième Classe
19 ⅜ × 25 ⅛ in.
The Cummer Museum of Art
& Gardens Archives

this period note his sketching expeditions to the Louvre, illuminate the family's support of his efforts, celebrate his first appearance at the Salon, and reflect their immense pride in his work in the ateliers ("I am the mother of a friend to the famous and celebrated Bonnat and Giacomotti, and in the future, their equal!!!").[7]

Like most art students at the time, Charvot studied the human figure in life drawing classes but focused on the newly popular genre of landscape. He cited study of the techniques of then-modern masters Paul-Jacques-Aimé Baudry (1828–1886), Jules Bastien-Lepage (1848–1884), and Henri Harpignies (1819–1916), but it was Harpignies who made the lasting impression.[8] Charvot exhibited landscapes in regional exhibitions and made his artistic debut in 1876 at the Salon with a view of the French countryside.

Charvot and the Paris Salon

Sponsored by the state, and later by the Société des Artistes Français, the annual Salons of the 1870s and 1880s were spectacular juried exhibitions where thousands of contemporary works were displayed each spring. Held at the immense Palais de l'Industrie, the presentations were reviewed by critics and were seen as a fashionable social event of the spring season. In Charvot's time, acceptance at the Salons was still a pivotal event for most artists, a symbol of artistic merit and recognition, and refusal was often traumatic. The Salon jurors, led by William-Adolphe Bouguereau (1825–1905), wielded great power and they were feared, revered, and reviled. In Charvot's debut year of 1876, more than half the works entered were refused.[9]

Charvot's acceptance was quite prestigious for a newcomer, but his next submission was rejected by "that revolting Bouguereau."[10] Happily, Charvot's landscapes made the cut in 1879, 1880, 1881, 1882, and 1884.[11] In these compositions, Charvot used what would become his most successful motifs – prairies, riverbanks, and cows – elements that he would revisit in his prints. The artist's later devotion to printmaking found renewed success at the Salon, with steady entries from 1902 to 1911. By that time, the Salon had diminished in stature due to the array of other exhibition opportunities in twentieth-century Paris and its rejection

by the avant garde, but it remained a desirable venue for exhibition, particularly in the eyes of older artists. The fact that Charvot was awarded an Honorable Mention in 1904 for a series of four prints and a subsequent Third-Class Medal in 1906 for six additional prints speaks to his status as a successful and respected artist (Fig. 3).[12]

Transformative Years in North Africa

From 1885 to 1889, Charvot began his most adventurous period as an artist. Stationed in French Tunisia, where he served in military hospitals, Charvot was first sent to Gabès, a lonely desert outpost far south of the capital, near the oasis communities of Djara and Menzel. In letters to his niece Henriette (Fig. 4), an art student, he described his impressions of the area, "This is a strange place for a French landscapist, an empty horizon of endless sand... happily there are compensations for the artist: an oasis begins with regularly planted palm trees receding into charming paths...the river becomes more picturesque... with rustic bridges formed from great blocks of stone...Djara...is constructed with the ruins of Tacape (a significant Roman city). There you see shacks resembling miniature temples with chicken coops made from fragments of columns and capitals...(Figs. 5–6)"[13]

In Djara, populated with Arab Muslim and Jewish inhabitants, Charvot began painting street scenes and interiors, the focus of his work in Tunisia. Unlike earlier artists referred to as Orientalists, who visited North Africa briefly or fabricated images of North Africa in their Parisian studios, Charvot was a documentarian, recording Tunisian life as he observed it.[14] He considered the streets his "landscape," and wrote about the "performance" which occurred there whenever he began to paint. "As soon as one sets up one's easel, the kids arrive to crouch around you. Arab men stop along the walls. ...The Arab women sit on the steps of their doorways. Donkeys pass loaded with four large amphorae and the young girls go to the fountain, their water jugs on their heads..."[15]

In the village interiors and streets, the exotic appearance of the Tunisians captivated him. "Here, figures are as important as nature," he stated, and he worked to develop his ability to render figures as an essential element. Lamenting his lack of figure study as a student in

Fig. 5

Eugène-Louis Charvot (1847–1924)
Untitled (*Figure with Palm Trees and a Mosque*), 1885
Ink, pencil, and watercolor on paper
2 ⅛ × 1 in.
Gift of Yvonne Charvot Barnett in memory of her
father Eugène-Louis Charvot
AG.1999.5.213

Paris, he wrote to Henriette, "your uncle, who did not take advantage of sufficiently studying figure drawing in Paris, can't yet make informed sketches." He concentrated on quickly working in pencil and oil, to improve his skills, and often sketched the young daughters of an acquaintance, subsequently noting, "Upon arrival, I wasn't capable of indicating a figure. Today, in ten minutes, I made a complete drawing of a small Arab girl, fully in costume…"[16]

The extreme and enervating heat of the desert made painting with oils during the summer impossible, but, maintaining his determination to submit pieces for the Salons, Charvot spent afternoons of the cooler months in pursuit of his goal. "I have abandoned neither painting nor the Salon and I think that I am making serious progress…," later adding, "I would like to reappear with a large, serious painting, important enough to be noticed. …I am in a country completely unexplored by painters and I want to make good of my setting before leaving. If my paintings aren't successful, it won't be for lack of trying or feeling."[17] During this period, Charvot began two large canvases, *Les bords de l'Oued – Gabès à Djara, Tunisie* and *Intérieur arabe à Djara, Tunisie*, both destined for the Salon of 1886. In his letters to Henriette, he described his process – detailing his palette of colors and the importance white played in giving other colors body and thickness. He also expressed his struggle to complete figures in the studio instead of in person as he would have preferred (Plate 1).

He described *Les bords de l'Oued* as follows: "I have settled on my choice for a painting for the Salon. It will be a small Arab woman carrying her pitcher on her shoulder and walking along the Gabès…with rocks and palm trees in the background…" Of the *Intérieur*, he wrote, "I continue to outline a canvas representing the interior of an Arabian house in Djara. Delicate and elegant pillars support an arch; an Arab woman and her daughter prepare couscous, which forms the basis of the Arabian diet. In the corner are some large amphorae of Djara and millstones used for grinding barley. The interior has much character and will be easy to do but the figures will make life difficult. Meanwhile, I work in watercolor."[18] These paintings were accepted in the Salon of 1886, and were sold afterwards. True to his working style,

Fig. 6

Eugène-Louis Charvot (1847–1924)
Djara, août (Djara, August), 1885
Ink, pencil, and watercolor on paper
3 ⅞ × 3 ⅞ in.
Gift of Yvonne Charvot Barnett in memory of
her father Eugène-Louis Charvot
AG.1999.5.212

Charvot used elements of both compositions in other works, *Le quartier juif de Djara* of 1886, and *Intérieur arabe à Tunis* of 1888 (Plates 2, 4).

In late 1885, the French painter Gustave Nicolas Pinel (1842–1896) arrived in Gabès for the winter. A fellow student of Bonnat and an award-winner at the Salon of 1885, Pinel made a great impression on Charvot, and the two men shared a studio in Djara. Charvot found it invigorating and inspiring to have a colleague, leading him to finish multiple canvases, including his striking composition, *Le petit meunier*, of a young man at a millstone (Plate 5). The strong lines and loose brushwork of this painting are departures from the more traditional perspectives of his street scenes, and Charvot credited Pinel with helping him capture the human form.[19] This collegial partnership lasted until Charvot's transfer to Tunis, Tunisia, in early 1886, where he remained for the rest of his tour of duty.

Located in a widely visited part of the Mediterranean, Tunisia was, by 1884, controlled by the French government. The country had an ancient history of trade and intermingling of cultures, with emigration by Phoenicians, Greeks, Romans, Vandals, Moors, Jews, Turks, Arabs, and Europeans. By the time Charvot arrived, the Arab and Bedouin majority made Tunisia a predominately Islamic country, with small but distinct Jewish and Christian minorities. Blessed with a mild, Mediterranean climate, Tunis, the principal port and capital, was a large city, cosmopolitan in nature and open to foreign ideas.[20]

In Tunis, Charvot continued to paint street scenes and interiors in the *medina*, the Arab quarter. His *La rue El-Halfaouine à Tunis*, exhibited at the Salon of 1890 and later in the Municipal Exposition of Geneva, Switzerland, of 1898, is a large canvas capturing the tempo of the city as Charvot observed it, and is the culmination of his view of the Arab world (Plates 7–8). The scene is a snapshot, a straightforward depiction of the various inhabitants of a street in the capital. While the subject matter was exotic to the European eye, it is not presented with an exaggerated sense of drama. Rather, as in his earlier village scenes, it is a quiet, truthful revelation of a different culture. "All is bright and colored, luminous and fresh," he wrote, "The cube-shaped houses...dabbed high and low with white lime, shine under the eastern sun like immense blocks of chalk...At every corner of these narrow and tortuous streets one sees the even, round dome of the mosque which soars in the blue sky, with a minaret surmounted by the crescent of the prophet (Fig. 7)."[21]

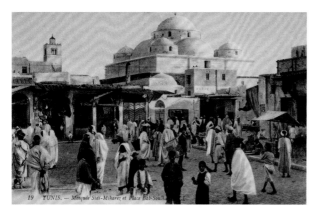

During his last years in Tunis, Charvot was visited by his friend and colleague, Émile Friant (1863–1932), the much-decorated French artist. Friant painted street scenes of the city and a portrait of Charvot (Plate 9). Seen in profile, dressed in his military uniform with a background reminiscent of an Oriental rug, the portrait is a blending of French and Tunisian elements. Kept in the family until its acquisition by the Cummer Museum, Charvot considered the portrait his most treasured possession.[22]

Tunis was also the meeting place of Charvot and Marie Angélique Eugénie Valéry de Rostino (known as Eugénie), the woman who would become his wife (Plates 10, 12). A native of Corsica, Eugénie was a young widow living in Tunis with her daughter, Gabrielle, when Charvot met her. Their eight-year courtship spanned Charvot's postings in Paris and Constantine, Algeria, and Charvot's pencil portraits of Eugénie from this period reflect their growing attachment. Like many artists, Charvot looked to Eugénie and Gabrielle, and later to his daughter Yvonne, for artistic inspiration (Plate 11). All three became models for his figures in paintings and prints, and Yvonne noted that her father always sketched at family gatherings, seeking to perfect his skills by capturing the moments of his beloved family circle. While niece Henriette did not model for her uncle, she became an artist and corresponded with him about art in letters and postcards throughout their lives (Fig. 8).

Return to France

In 1899, the Charvots settled in Créteil, a village outside of Paris (Plates 13, 42–43). This geographic move signaled the second and most important phase of Charvot's artistic career. Now retired from the military and able to devote all of his time to art, Charvot continued to paint in oil but was introduced to etching in 1901. In the diary he kept at the time, he wrote, "Blessed, three times blessed the day when I decided to bite a drawing on copper. ...Since childhood, I had adored the genre of printing, but never dared to try it. I thought that creating etchings was extremely difficult, a veritable art of alchemy, necessitating a long apprenticeship and accessible only to those rare initiates. I soon saw it wasn't so. ...I was conquered by etching."[23]

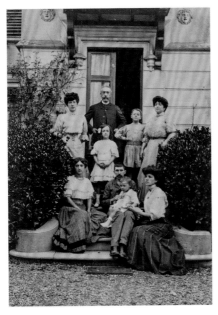

A chance encounter with a young print-maker introduced Charvot to etching, but he was primarily self-taught in the medium. Aided by a book of instructions, his love of drawing, and his technical skill as a surgeon, he worked alone in a studio at his home. While Charvot's larger and more important works were produced by printer Louis Fort in Paris, he often experimented with smaller works on his own. In his print diary, he chronicled the states that each work went through, citing acid baths, areas of drypoint, and experiments with tonalities and colors.

For subject matter, Charvot returned to the pastoral figures and animals which had fascinated him during his youth. "For many years, I exhibited paintings of the Orient at the Salons, that were valued by artists and by collectors, but I didn't become an Orientalist," he reflected. "I remained, always, haunted by memories of the fields of the Bourbonnais and I continued to make landscapes with animals and figures. ...Landscapes, animals and agrarian figures are the elements with which I have sought to express on canvas or copper the sensations that I feel in the presence of nature (Plates 17–18)."[24]

The representation of nature for Charvot almost always included an image of a cow, and he wrote of their simple beauty and gentleness in his diary (Fig. 9). Citing the Dutch tradition of animal painting and engraving as inspiration, his depictions of a single cow in a landscape were a way for him to focus on one motif from the very start of a composition and reflected his belief that landscapes should not contain too many competing elements.[25] *Vache blanche au coin d'un bois* from 1902 is one of his first efforts at etching (Plates 15–16). As he achieved more experience working with the copper plate, Charvot added vigorous and poetic details to draw viewers into his work. *La sieste* from 1904 with its increased depth of field (Plates 19–20), *Un coin de prairie* (Plate 21) from 1907 with its sense of movement and water reflection, and *L'orage* from 1910 with cows serving as a metaphor for the insignificance of the earth's creatures when faced with the sky's power, illustrate this progression (Plate 22).

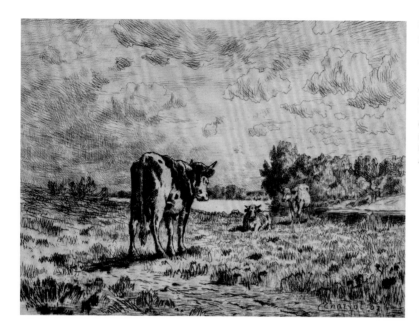

Fig. 9

Eugène-Louis Charvot
(1847–1924)
Vaches au bord de la Marne
(*Cows Grazing on the Banks
of the Marne*), 1901
Etching on paper
10 × 13 in.
Gift of Yvonne Charvot Barnett
in memory of her father Eugène-
Louis Charvot
AG.1999.5.70

Charvot found his cows to be popular both at the Salons and for publication, and many were published by the journal *L'Art* or by the Société des Aquafortistes for distribution as their annual print.[26] In some instances, Charvot produced limited editions of his prints. To insure a limited production, he would buy back a plate from a publisher and then destroy it after the edition was printed.

In a series of five prints produced from 1902 to 1904, Charvot focused again on a single motif, this time picturesque and romantic representations of a peasant girl. Influenced by the work of French artists Jean-François Millet (1814–1875) and Jules Breton (1827–1906), the series of portraits set in the fields reflects his desire to explore different moods and capture the spirit of an idealized view of life. A great admirer of Millet for his "grand and sad poetry," Charvot did not like Millet's portrayal of the worker as "condemned by destiny to suffering, deformed by harsh labor." Looking to the more idealized work of Breton, Charvot noted "we are no longer in a lamentable era...material conditions have changed, and today the young girl...can take on all the fullness and beauty of the feminine form."[27]

In the first portrait, *Paysanne sous la feuillée*, he sought to evoke the carefree and soft atmosphere of a girl lost in reverie (Plates 23–24). The second, *Paysanne en plaine*, began as a simple drawing of Gabrielle, his step-daughter, sketched after a morning spent working in the garden (Figs. 10–11) (Plates 25–26). In his diary, Charvot noted that he tried to achieve a somber note in the pose, a sense of preoccupation. The third and fourth iterations, *Petite fille faisant boire sa vache* and *Paysanne au crépuscule*, also modeled by Gabrielle, further explored

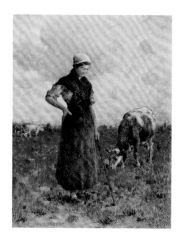

Fig. 10
Eugène-Louis Charvot (1847–1924)
Sketch of Gabrielle (Charvot's Step-Daughter) for "Paysanne en plaine"
c. 1902
Pencil
7 ¾ × 4 ¾ in.
Charvot Family Archives

Fig. 11
Eugène-Louis Charvot (1847–1924)
Paysanne en plaine (Peasant Girl in the Field), 1902
Etching, drypoint, watercolor, and gouache
13 ⅝ × 10 ¼ in.
Gift of Yvonne Charvot Barnett in memory of her father Eugène-Louis Charvot
AG.1999.5.45 (Plate 26)

the theme (Plates 27–28). Of this image Charvot wrote, "A peasant watches over her flock, standing upright proudly...resembling a goddess of the meadows rather than a herder. Who could not envy her? She has youth, health, and, in spite of her fierce air, beauty."[28] Charvot later created a fifth print, *Paysanne allant à la pêche* (Plates 29–30). This last effort is considered one of his best etchings because it captures the spontaneity and idyllic quality of an early-morning moment of leisure.

The series allows an understanding of Charvot's working method as a printer. He usually began by making pencil sketches in the fields followed by a detailed preparatory drawing, which sometimes varied in scale from the finished print. After the etched copper plate was immersed in an acid bath, Charvot, like many artists, would modify the image, using drypoint to create lines of velvety richness. In search of variation, he changed scale, adapting his compositions to the smaller formats of postcards and stationery. Charvot often hand-colored his prints with watercolor and gouache. Finding that colored versions sold well, a reflection of the popularity of tinted prints at the turn of the twentieth century, Charvot manipulated different states of the same plate to give the prints a painterly feel. By choosing pinks, lavenders, and deep blues, he could create a very different mood from the black-and-white versions.

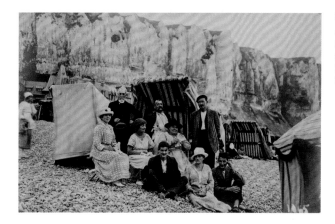

In his print journal, Charvot repeatedly addressed his love of moonlight, feeling that etching was well suited to defining the tranquility and atmosphere of the night sky. His search for emotional expression, first seen in his *Paysanne* series, is investigated in *Nocturne no. 1 (la perle) peuplier*, through an experimental manipulation of ink color (Plates 35–36). In *Nocturne no. 3, Effet de lune, Village de Recloses*, a study of moonlight in a village near the forest of Fontainebleau, Charvot became a painter and printmaker in a new way (Plate 37). Instead of adding painted color to a black-and-white print, Charvot first used an aquatint plate to establish green background color, with some areas left white for the moonlight. He then overlaid a second etched and inked plate, rendering the lines to complete the composition of a silent and still village night.

One of Charvot's masterpieces as a printmaker is *Paysanne brûlant des herbes au crépuscule*, which was accepted in the Salon of 1905 (Plates 31–34). In it, Charvot used a gently smoking fire to capture the atmospheric stillness of a late summer evening. He wrote, "Exhibited... in the best spot in the etching room, it attracted the attention of the printers and also of the painters for the vigor of the dark and luminous spots, and for the power of the coloration." Charvot believed the Third-Class Medal he received the following year was a result of the positive impression this print made.[29]

Charvot traveled in France with family and friends (Évreux, Ault-Onival, Saint-Valery-sur-Somme, Recloses, Grez-sur-Loing) and he came away from these trips with a body of work created on location. *La vieille tour de l'horloge à Évreux*, developed from sketches made in 1905, was one in a series of views produced for a portfolio of the town commissioned by local bookseller Charles Lebigre (Plates 40–41).[30] The artist's depiction of the tower – which earned a medal at the Salon of 1906 – was so popular that Charvot created a later view from a different vantage point for additional individual sale. The folio was reprinted with a new frontispiece showcasing the entire city, and Charvot repeated selections from the portfolio as postcards (Plate 38). Like other artists before him, the inherent versatility

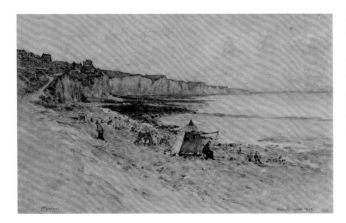

Fig. 13

Eugène-Louis Charvot
(1847–1924)
Onival, 1912
Watercolor
7 13/16 × 8 in.
Gift of Yvonne Charvot
Barnett in memory of her
father Eugène-Louis Charvot
AG.1999.5.85

of printmaking, and its appealing commercial value, allowed Charvot to share his work through different formats, and to cater to different audiences.[31]

But not all vacation pursuits were excuses for commercial efforts. In Ault-Onival, where the Charvots summered, the family enjoyed picnics on the beach and large family gatherings (Fig. 12). First discovered by the Impressionists, Onival's picturesque character and easy proximity to Paris made it a popular retreat for artists. While there, Charvot worked in watercolor, capturing the high cliffs and expansive views in carefree visions of summer at the shore (Fig. 13).[32]

Final Years

No records exist of Charvot's printmaking after 1913, although he served as president of the Société des Aquafortistes Français in 1922. He continued to print from existing plates, but the family's return to Paris left him without a studio. Because of that, and perhaps due to advancing age, he reverted to sketching in pencil, ink, and watercolor, creating views of Paris, in a variety of scales and formats, for sale to tourists (Plates 44–46). Although Charvot professed a disapproval of Modernism, he became interested in the work of Henri-Jean Guillaume Martin (1860–1943), who worked in an Impressionist and Pointillist style, and Martin's influence can be seen in the loose, punctuated brushwork of his late watercolors (Plate 47).

Charvot continued to teach and work with private students, something he had done earlier in Tunisia and Créteil, and, having achieved prominence in both of his chosen fields, he worked steadily as an artist until his sudden death from a stroke in 1924. After his death, Charvot's legacy as physician, painter, and printmaker was preserved by his descendants and now lives on at the Cummer Museum of Art & Gardens as the Eugène-Louis Charvot Collection.[33]

NOTES

1. All biographical chronology for Eugène-Louis Charvot comes from "Chronology of the Life of Eugène-Louis Charvot," Claudia Barnett Gordon, 1988, Charvot Family Archives.

2. Eugène-Louis Charvot to Henriette Charvot, Gabès, Tunisia, 2 November 1885, The Eugène-Louis Charvot Collection, The Cummer Museum of Art & Gardens Archives.

3. Eugène-Louis Charvot, draft of letter with artist's statement, 22 July 1914, Family Archives.

4. For biographical information on all artists cited, see Emmanuel Bénézit, ed., Dictionnaire critique et documentaire des peintres, sculpteurs, dessinateurs et graveurs, 1st ed., 14 vols. (Paris: Éditions Gründ, 1990); Jane Turner, ed., The Grove Dictionary of Art, 34 vols. (New York: Macmillan Publishers Limited, 1996).

5. Eugène-Louis Charvot to Henriette Charvot, Gabès, Tunisia, 4 August and 18 August 1885, Charvot Collection.

6. Eugène-Louis Charvot, "Chemin creux aux environs de Bourbon l'Archambault," 1902, Histoire de mes Eaux Fortes, Charvot Collection.

7. Edme Elizabeth Blanchard-Lavalette to her son Eugène-Louis Charvot, Moulins, France, December 1875, March and July 1876, Family Archives.

8. Eugène-Louis Charvot to Henri Revers, draft of letter with artist's statement, 1903, Family Archives.

9. For the Paris Salons, see Lois Marie Fink, American Art at the Nineteenth-Century Paris Salons (New York: Cambridge University Press, 1990); Gerald M. Ackerman, "The Glory and Decline of a Great Institution," in French Salon Paintings from Southern Collections (Atlanta, Ga.: The High Museum of Art, 1983), pp. 8–23; Diane P. Fischer, "Paris 1900: The American School," American Art Review, Vol. XI, No. 6, 1999, pp. 198–224; Jane Mayo Roos, Early Impressionism and the French State (1866–1874) (New York: Cambridge University Press, 1996); Patricia Mainardi, The End of the Salon: Art and the State in the Early Third Republic (New York: Cambridge University Press, 1993); Kathleen Adler, "'We'll Always Have Paris': Paris as Training Ground and Proving Ground," in Americans in Paris 1860–1900 (London: The National Gallery, 2006), pp. 11–55.

10. Eugène-Louis Charvot to Henriette Charvot, Gabès, Tunisia, 26 October 1885 and La Goulette, Tunisia, 27 January 1886, Charvot Collection.

11. Charvot exhibited oil paintings at the Salon in 1876, 1879, 1880, 1881, 1882, 1884, 1886, 1887, 1890, 1898, 1902, and 1903. He exhibited prints at the Salon in 1902, 1904, 1905, 1906, 1907, 1908, 1909, and 1911. Salon entries detailed in Salon catalogs: Explication des ouvrages de peinture, sculpture, architecture, gravure et lithographie des artistes vivants, published in Paris in the years noted.

12. Honorable Mention in 1904 awarded for four prints: Paysanne sous la feuillée; Paysanne en plaine gardant sa vache; Petite fille faisant boire sa vache; Paysanne au crépuscule; Third-Class Medal awarded in 1906 for six prints: La vieille tour de l'horloge à Évreux; Au bord de l'eau (L'Art); La maison du grand-veneur à Évreux; La sieste (L'Art); Vache au coin d'un bois (L'Art); Nocturne. Société des Artistes Français, Explication des ouvrages de peinture, sculpture, architecture, gravure et lithographie des artistes vivants, exposés au Grand Palais des Champs Élysées (Paris: Imprimerie Paul Dupont, 1904 and 1906).

13. Eugène-Louis Charvot to Henriette Charvot, Gabès, Tunisia, 25 March 1885, Charvot Collection.

14. For Orientalism, see Edward W. Said, Orientalism (New York: Random House Inc., 1979); Linda Nochlin, "The Imaginary Orient," Art in America, May 1983, pp. 121–91; Donald A. Rosenthal, Orientalism (Rochester, NY: Memorial Art Gallery, 1982); Christine Peltre, Orientalism in Art (New York: Abbeville Press, 2005); Nathalie Bondil, Benjamin-Constant: Marvels and Mirages of Orientalism (Paris: Editions Hazan, 2015).

15. Eugène-Louis Charvot to Henriette Charvot, Gabès, Tunisia, July 1885, Charvot Collection.

16. Eugène-Louis Charvot to Henriette Charvot, Gabès, Tunisia, July, 27 November and 5 December 1885, Charvot Collection.

17. Eugène-Louis Charvot to Aline Charvot, Gabès, Tunisia, 20 July 1885 and Charvot

to Henriette Charvot, Gabès, Tunisia, 2 November 1885, Charvot Collection.

18. Eugène-Louis Charvot to Henriette Charvot, Gabès, Tunisia, 18 August and 26 October 1885, Charvot Collection.

19. Eugène-Louis Charvot to Henriette Charvot, Gabès, Tunisia, 27 November; 5, 14, and 20 December 1885; and 3 January 1886, Charvot Collection.

20. For Tunisia and North Africa, see Norman Itzkowitz, *Ottoman Empire and Islamic Tradition* (New York: Alfred A. Knopf, Inc., 1972); P. Foncin, *Géographie* (*Première Année*) *Cours Moyen*, 229th edition (Paris: Forcin Librairie Armand Conlin, 1916); Gabrielle Sed-Rajna, *Jewish Art* (New York: Harry N. Abrams, Inc. 1997); Richard Ettinghausen, *Arab Painting* (Cleveland: The World Publishing Company, 1962); Sükrü M. Hanioğlu, *A Brief History of the Late Ottoman Empire* (Princeton: Princeton University Press, 2010); Jennifer Meagher, "Orientalism in 19th Century Art," *Heilbrunn Timeline of Art History* (New York: The Metropolitan Museum of Art, October 2004).

21. Eugène-Louis Charvot to Henriette Charvot, La Goulette, Tunisia, 17 February 1885, Charvot Collection.

22. Yvonne Charvot Barnett, interview by author, Jacksonville, Florida, autumn 1999.

23. Eugène-Louis Charvot, "Petite étude de vache vue par derrière," 1901, *Histoire de mes Eaux Fortes*, Charvot Collection.

24. Eugène-Louis Charvot, draft of letter with artist's statement, 22 July 1914, Charvot Collection.

25. Eugène-Louis Charvot to Henriette Charvot, Gabès, Tunisia, 25 August 1885, Charvot Collection.

26. Charvot's prints appeared in the journal *L'Art* in 1904: *La sieste*; *Paysanne sous la feuillée*; *Paysanne en plaine*; *Vache blanche au coin d'un bois*; and in 1907: *Chemin creux aux environs de Bourbon-l'Archambault* and *Paysanne allant à la pêche*, renamed *Au bord de l'eau*. Prints also appeared in the journal *Revue de l'art ancien et moderne* in 1903: *Paysanne faisant boire sa vache*, with an image of Paris, a brief biography, and an engraved portrait of Charvot; and in 1913: *Deuxième vue, La vieille tour de l'horloge à Évreux*. The Société des Aquafortistes purchased *Vache au coin de prairie* and *L'orage* for distribution as their annual print in 1904 and 1912 respectively. Eugène-Louis Charvot, *Histoire de mes Eaux Fortes*, Charvot Collection.

27. Eugène-Louis Charvot, "Paysanne allant à la pêche," 1904, *Histoire de mes Eaux Fortes*, Charvot Collection.

28. Eugène-Louis Charvot, "Paysanne au crépuscule," 1903, *Histoire de mes Eaux Fortes*, Charvot Collection.

29. Eugène-Louis Charvot, "Paysanne brûlant des herbes au crépuscule," 1904, *Histoire de mes Eaux Fortes*, Charvot Collection.

30. Eugène-Louis Charvot to Charles Lebigre, 19 May 1914, Paris, France, and Lebigre to Charvot, 22 May 1914, Paris, France, Family Archives.

31. Eugène-Louis Charvot, "Deuxième vue, La vieille tour de l'horloge à Évreux," 1908, *Histoire de mes Eaux Fortes*, Charvot Collection.

32. For more information on artists' summers in France, see Barbara H. Weinberg, "Summers in the Country," in *Americans in Paris 1860–1900* (London: National Gallery Company Limited, 2006), pp. 115–77.

33. Yvonne Charvot Barnett, interview by author, Jacksonville, Florida, autumn 1999.

PLATES

Plate 1
—

(detail) Sketch of **"Les bords de l'Oued – Gabès à Djara, Tunisie"**
From Charvot's letter to his niece Henriette (July, 1995)
1885, ink

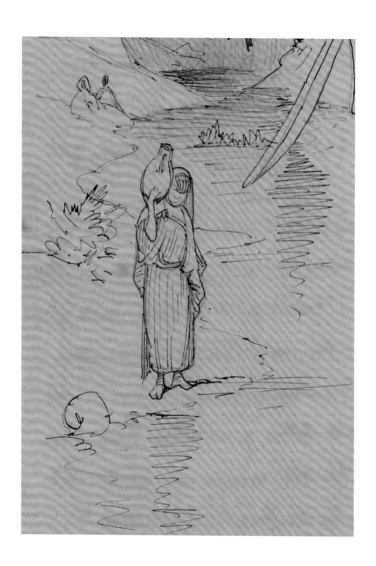

Plate 2
—

Le quartier juif de Djara
(The Jewish Quarter of Djara)
1886, oil on canvas

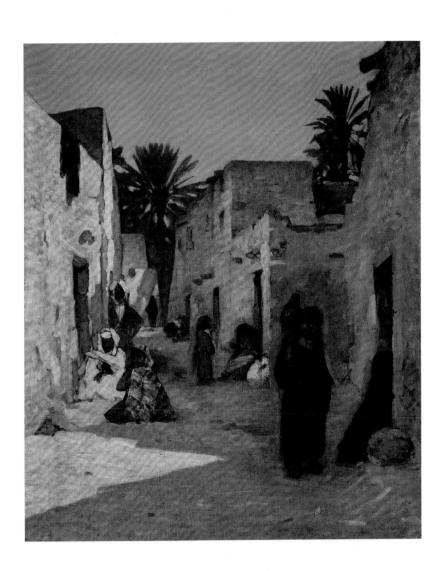

Plate 3

Intérieur arabe à Djara, Sud-Tunisien
(Arab Interior, Djara, Tunisia)
1886, oil on canvas

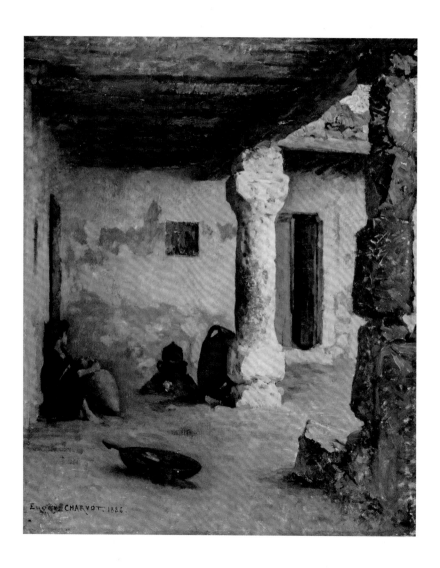

Plate 4
—

Intérieur arabe à Tunis
(Arab Interior, Tunis)
1888, oil on canvas

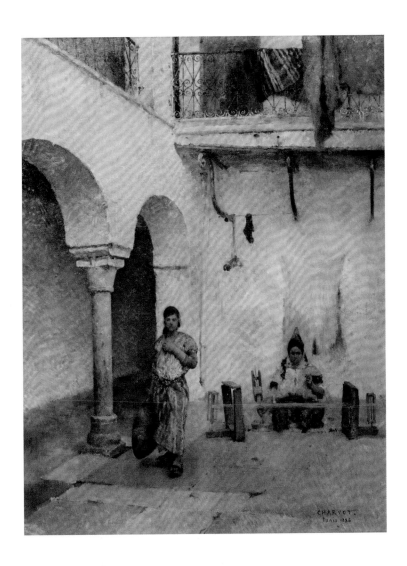

Plate 5
—

Le petit meunier
(The Little Miller)
c. 1886, oil on canvas

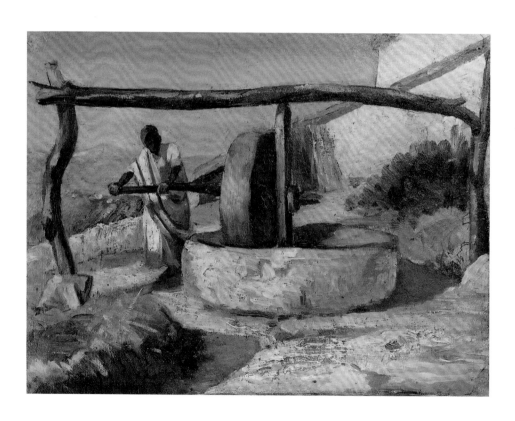

Plate 6

—

La rue du Pacha à Tunis
(Pacha Street, Tunis)
1889, oil on canvas

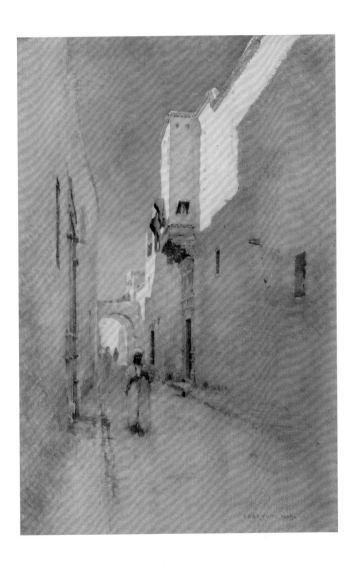

Plate 7
—

Study of an Arab Nobleman for "La rue El-Halfaouine à Tunis"
1889, oil on canvas

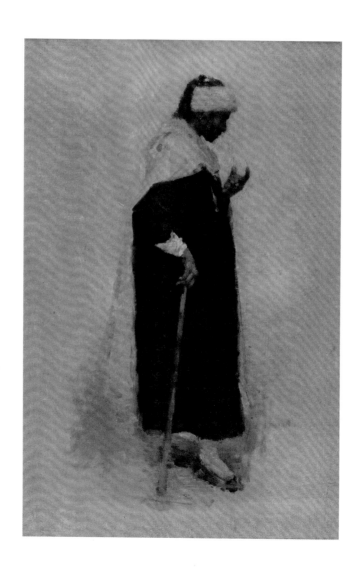

Plate 8
—

La rue El-Halfaouine à Tunis
(El-Halfaouine Street, Tunis)
1889, oil on canvas

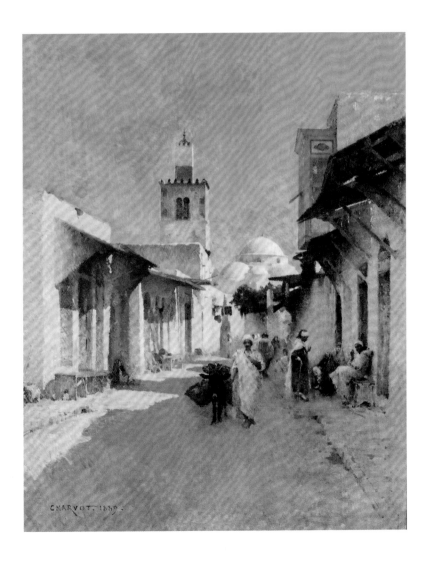

Plate 9
—

Émile Friant (1863–1932)
Portrait of Eugène Charvot
c. 1888, oil on canvas

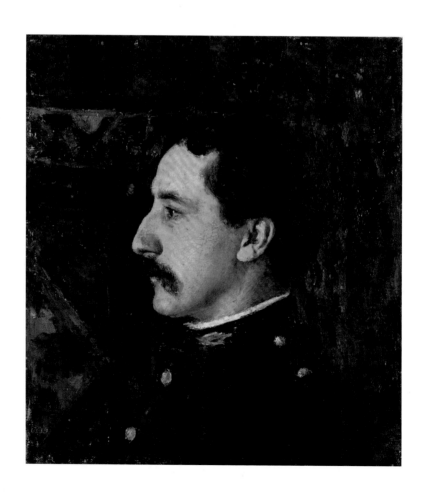

Plate 10
—

Marie Angélique Eugénie Valéry de Rostino
1892, pencil on paper

Plate 11
—

Yvonne
c. 1904, crayon on paper

Plate 12
—

Wedding Portrait of Madame Charvot
1897, oil on canvas

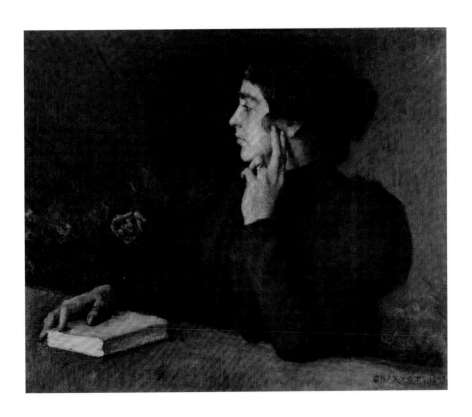

Plate 13
—

Les bords de la Marne, Créteil
(The Banks of the Marne, Créteil)
c. 1900, pencil on paper

Plate 14
—

Paysanne portant un seau d'eau
(Peasant Girl Carrying a Water Pail)
1900, oil on canvas

Plate 15
—

Vache blanche au coin d'un bois
(White Cow in the Woods)
1902, etching and drypoint on paper

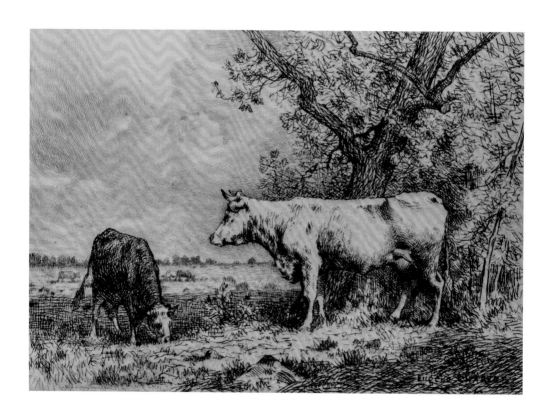

Plate 16
—

Vache blanche au coin d'un bois
(White Cow in the Woods)
c. 1902, oil on canvas

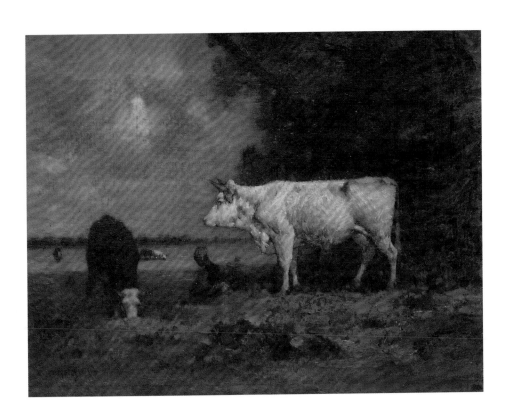

Plate 17
—

Chemin creux aux environs de Bourbon-l'Archambault
(Sunken Lane near Bourbon-l'Archambault)
1898, watercolor on paper

Plate 18
—

Chemin creux aux environs de Bourbon-l'Archambault
(Sunken Lane near Bourbon-l'Archambault)
1902, etching and drypoint on paper

Plate 19
—

La sieste
(The Nap)
1904, etching with pencil, watercolor, and gouache on paper

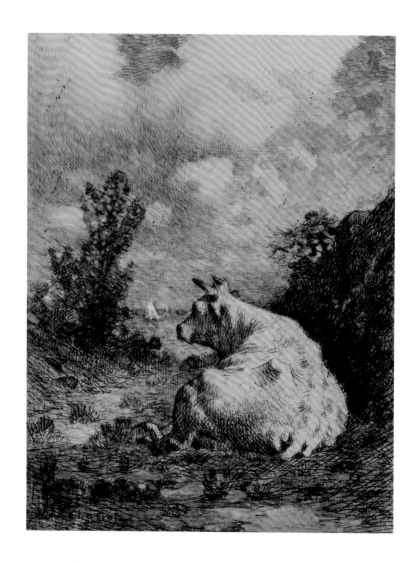

Plate 20
—

La sieste
(The Nap)
1904, etching and drypoint on paper

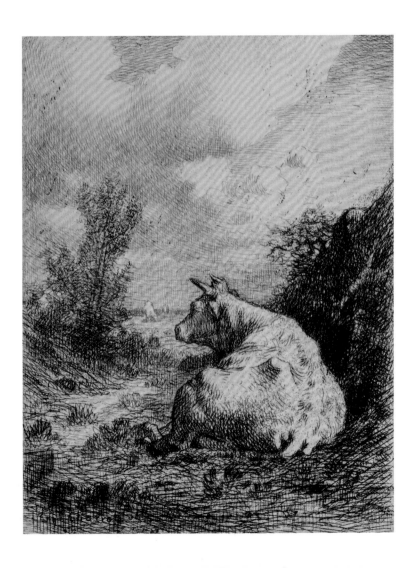

Plate 21
—

Un coin de prairie
(In the Meadow)
1907, etching and drypoint on paper

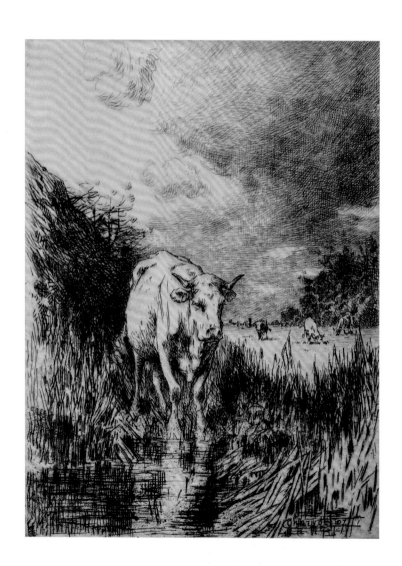

Plate 22

—

L'orage
(The Storm)
1910, etching and drypoint on paper

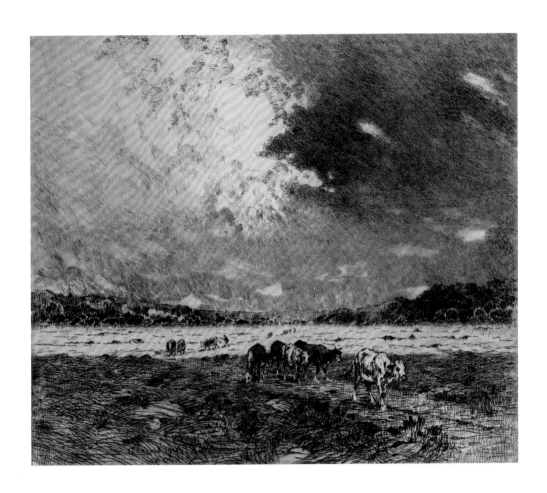

Plate 23
—

Paysanne sous la feuillée
(Peasant Girl under the Leaves)
1902, etching and drypoint on paper

Plate 24
—

Paysanne sous la feuillée
(Peasant Girl under the Leaves)
c. 1902, hand-colored etching on paper

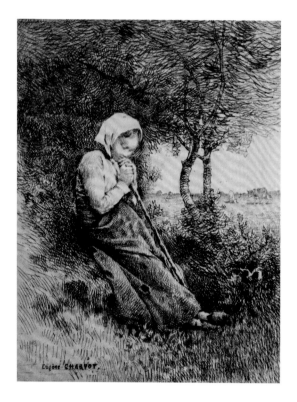

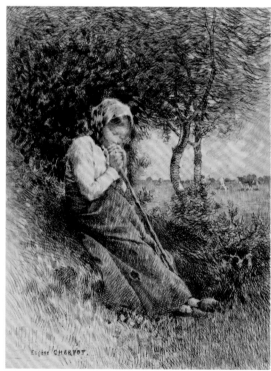

Plate 25
—

Paysanne en plaine
(Peasant Girl in the Field)
1902, etching and drypoint on paper

Plate 26 (Fig. 11)
—

Paysanne en plaine
(Peasant Girl in the Field)
1902, etching, drypoint, watercolor and gouache on paper

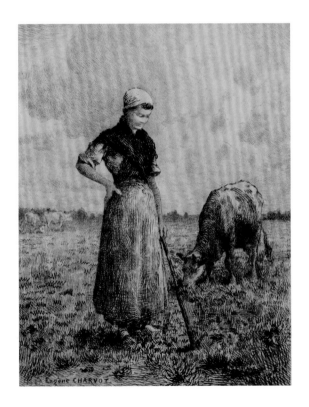

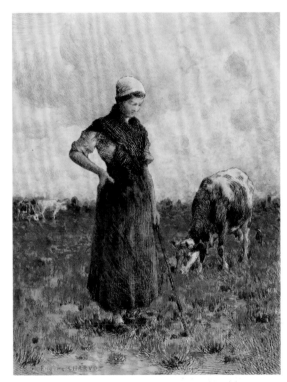

Plate 27

—

Paysanne au crépuscule
(Peasant Girl at Twilight)
1903, etching and drypoint on paper

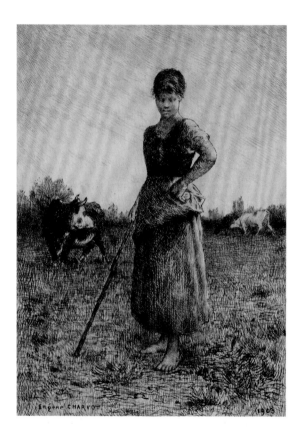

Plate 28

—

Paysanne au crépuscule
(Peasant Girl at Twilight)
1903, etching and drypoint with watercolor and gouache on paper

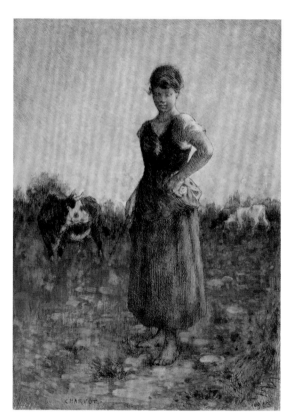

Plate 29
—

Paysanne allant à la pêche
(Peasant Girl Going Fishing)
1904, etching and drypoint on paper

Plate 30
—

Paysanne allant à la pêche
(Peasant Girl Going Fishing)
1904, etching and drypoint with pencil, watercolor, and
gouache on paper

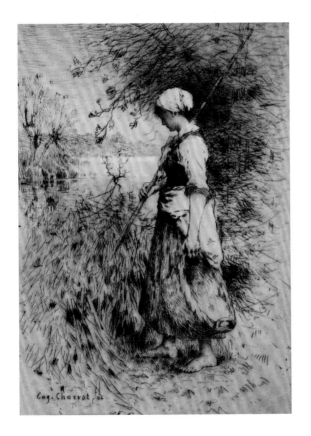

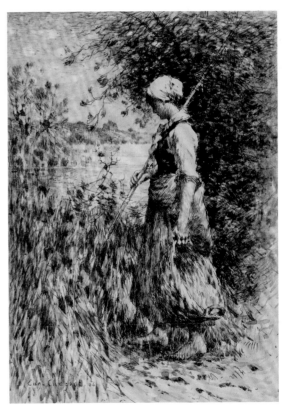

Plate 31
—

Paysanne brûlant des herbes au crépuscule
(Peasant Girl Burning Grass at Twilight)
1900, pencil on paper

Plate 32
—

Paysanne brûlant des herbes au crépuscule
(Peasant Girl Burning Grass at Twilight)
c. 1904, etching, drypoint, and chine collé on paper

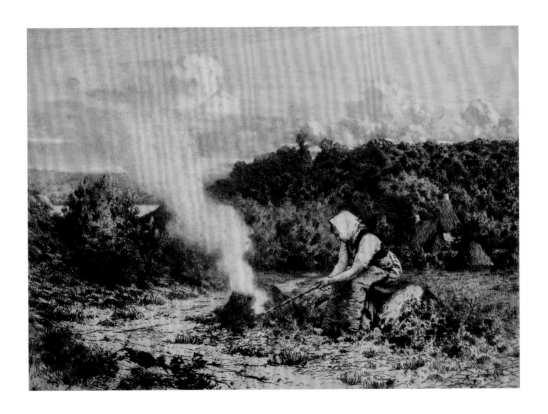

Plate 33
—

Paysanne brûlant des herbes au crépuscule
(Peasant Girl Burning Grass at Twilight)
1904, hand-colored etching and drypoint on paper

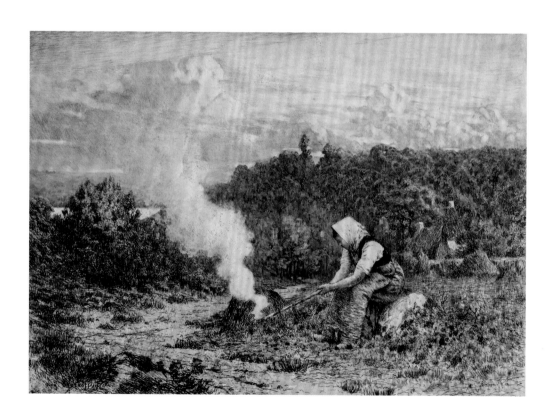

Plate 34

—

Paysanne brûlant des herbes au crépuscule
(Peasant Girl Burning Grass at Twilight)
1904, etching and drypoint on paper

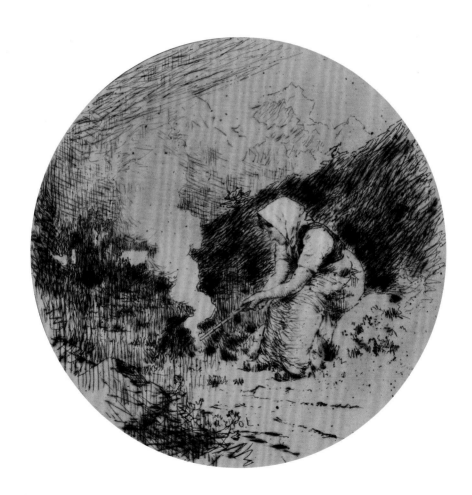

Plate 35

—

Nocturne no. 1 (la perle) peuplier
(Nocturne no. 1 (The Pearl) Poplar)
1903, etching and drypoint on paper

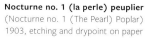

Plate 36

—

Nocturne no. 1 (la perle) peuplier
(Nocturne no. 1 (The Pearl) Poplar)
1903, etching and drypoint on paper

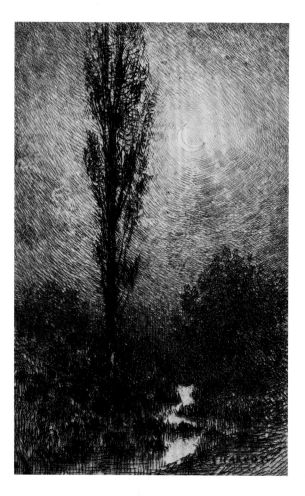

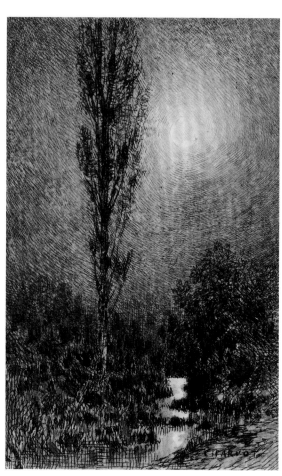

Plate 37

—

Nocturne no. 3, Effet de lune, Village de Recloses
(Nocturne no. 3, Moonlight, Village of Recloses)
1910, etching and drypoint on paper

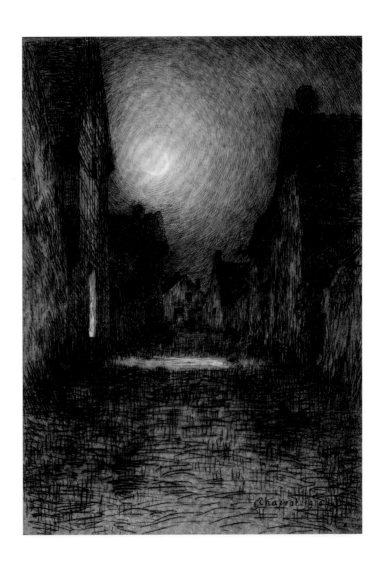

Plate 38
—

Croquis du frontispice pour l'album du vieil Évreux
(Sketch of the Frontispiece for the Album of Old Évreux)
1906, pencil on paper

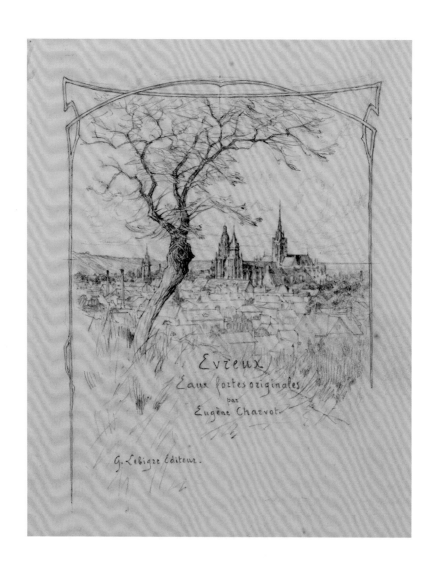

Plate 39
—

La cathédrale Notre-Dame d'Évreux
(Notre-Dame Cathedral, Évreux)
1905, etching and drypoint on paper

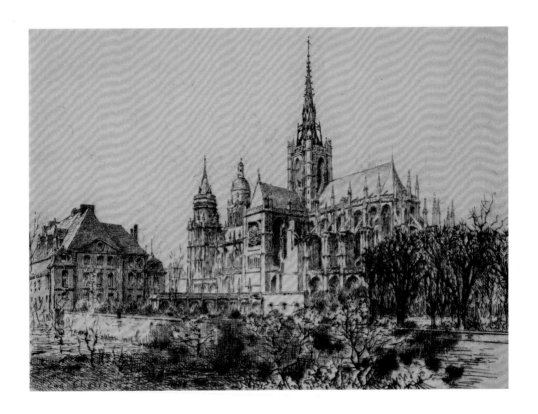

Plate 40
—

La vieille tour de l'horloge à Évreux
(The Old Clock Tower, Évreux)
1905, etching and drypoint on paper

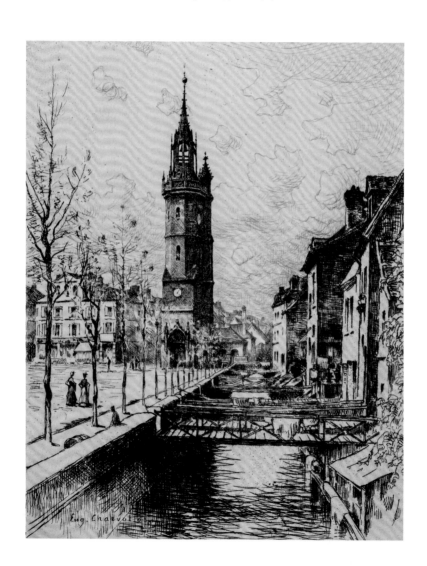

Plate 41
—

Deuxième vue, La vieille tour de l'horloge à Évreux
(The Old Clock Tower, Évreux, Second View)
1908, etching and drypoint on paper

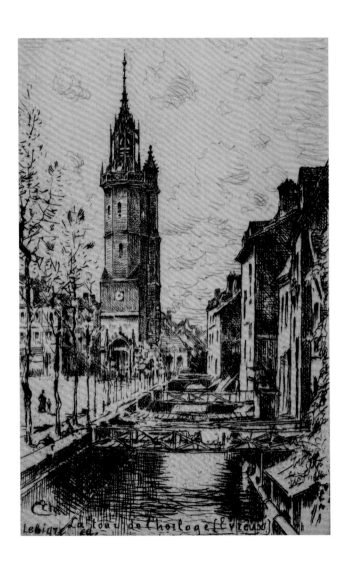

Plate 42
—

Bonneuil-sur-Marne
1908, oil on canvas

Plate 43
—

Bonneuil-sur-Marne
1908, oil on canvas

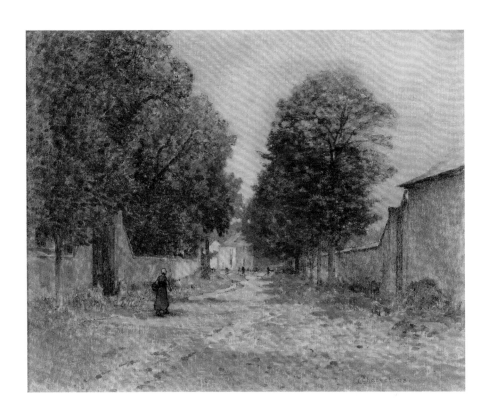

Plate 44
—

Parisian Street Scene
c. 1912, pencil and watercolor on paper

Plate 45
—

Arc de Triomphe at Dusk
c. 1912, watercolor on paper

Plate 46
—

Notre-Dame Cathedral
c. 1912, pencil on paper

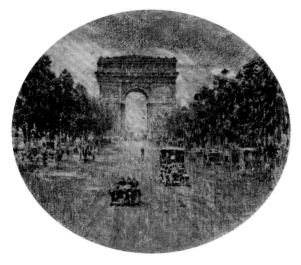

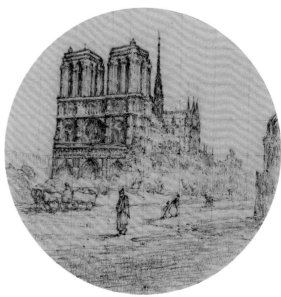

Plate 47
—

La porte de l'Aval, Mirepoix
(The Aval Gate, Mirepoix)
1918, watercolor on paper

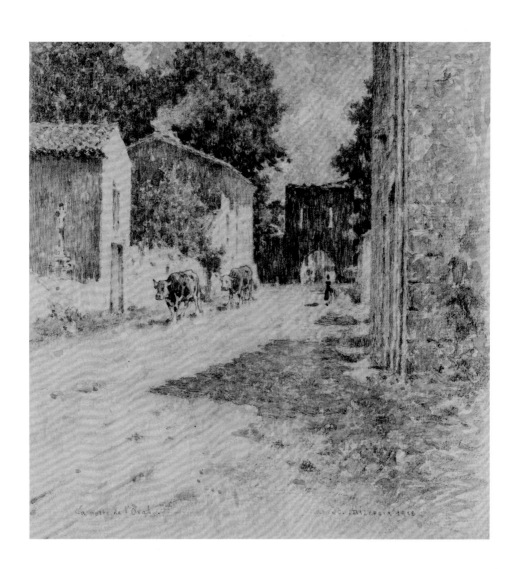

LIST OF WORKS

Unless otherwise noted, these works are in the collection of the Cummer Museum of Art & Gardens.
French titles of certain works were given by the artist in his diary.
Dimensions provided are framed measurements, or full sheets for works on paper.

Plate 1
Sketch for "Les bords de l'Oued – Gabès à Djara, Tunisie," 1885, ink, 8 ¹/₁₆ × 5 in., The Cummer Museum of Art & Gardens Archives

Plate 2
Le quartier juif de Djara (The Jewish Quarter of Djara), 1886, oil on canvas, 16 ½ × 12 ³/₁₆ in., Collection of Marie José Coll. © Photo credit Gilles Maloberti. Charvot refers to this work in a letter to Henriette (1885) as *Rue des Juifs, Djara*.

Plate 3
Intérieur arabe à Djara, Sud-Tunisien (Arab Interior, Djara, Tunisia), 1886, oil on canvas, 26 ¾ × 22 ⅞ in., AG.1999.5.5.

Plate 4
Intérieur arabe à Tunis (Arab Interior, Tunis), 1888, oil on canvas, 38 ⅝ × 31 ½ in., AG.1999.5.4.

Plate 5
Le petit meunier (The Little Miller), c. 1886, oil on canvas, 8 ⅜ × 11 in., Collection of Sarah Frank. © Photo credit David Scouri.

Plate 6
La rue du Pacha à Tunis (Pacha Street, Tunis), 1889, oil on canvas, 37 ¾ × 28 ½ in., AG.1999.5.1.

Plate 7
Study of an Arab Nobleman for "La rue El-Halfaouine à Tunis," 1889, oil on canvas, 19 ½ × 14 ¼ in., AG.1999.5.8.

Plate 8
La rue El-Halfaouine à Tunis (El-Halfaouine Street, Tunis), 1889, oil on canvas, 47 ¼ × 39 ⅞ in., AG.1999.5.3.

Plate 9
Émile Friant (1863–1932), *Portrait of Eugène Charvot,* c. 1888, oil on canvas, 16 ¼ × 15 in., AG.1999.5.17.

Plate 10
Marie Angélique Eugénie Valéry de Rostino, 1892, pencil on paper, 10 ⅛ × 8 in., AG.1999.5.125.

Plate 11
Yvonne, c. 1904, crayon on paper, 12 ¾ × 9 ½ in., AG.1999.5.123.

Plate 12
Wedding Portrait of Madame Charvot, 1897, oil on canvas, 19 ¾ × 23 ¼ in., AG.1999.5.13.

Plate 13
Les bords de la Marne, Créteil (The Banks of the Marne, Créteil), c. 1900, pencil on paper, 14 ⅞ × 18 ¼ in., AG.1999.7.2.

Plate 14
Paysanne portant un seau d'eau (Peasant Girl Carrying a Water Pail), 1900, oil on canvas, 13 × 16 in., Collection of the Charvot Family.

Plate 15
Vache blanche au coin d'un bois (White Cow in the Woods), 1902, etching and drypoint on paper, 10 ¾ × 14 in., AG.1999.5.39.

Plate 16
Vache blanche au coin d'un bois (White Cow in the Woods), c. 1902, oil on canvas, 8 ½ × 10 ¾ in., Collection of the Charvot Family.

Plate 17
Chemin creux aux environs de Bourbon-l'Archambault (Sunken Lane near Bourbon-l'Archambault), 1898, watercolor on paper, 9 ⅜ × 9 ⅞ in., AG.1999.5.33.

Plate 18
Chemin creux aux environs de Bourbon-l'Archambault (Sunken Lane near Bourbon-l'Archambault), 1902, etching and drypoint on paper, 10 ¾ × 13 ⅞ in., AG.1999.5.32.

Plate 19
La sieste (The Nap), 1904, etching with pencil, watercolor, and gouache on paper, 10 ⅛ × 9 ⅜ in., AG.1999.5.51.

Plate 20
La sieste (The Nap), 1904, etching and drypoint on paper, 12 ⅞ × 10 in., AG.1999.6.12.

Plate 21
Un coin de prairie (In the Meadow), 1907, etching and drypoint on paper, 12 × 9 ¼ in., AG.1999.5.64.

Plate 22
L'orage (The Storm), 1910, etching and drypoint on paper, 14 ¼ × 21 ¾ in., AG.1999.5.68.

Plate 23
Paysanne sous la feuillée (Peasant Girl under the Leaves), 1902, etching and drypoint on paper, 12 ⅞ × 9 ¾ in., AG.1999.6.7.

Plate 24
Paysanne sous la feuillée (Peasant Girl under the Leaves), c. 1902, hand-colored etching on paper, 13 ¼ × 10 ⅛ in., AG.1999.5.30.

Plate 25
Paysanne en plaine (Peasant Girl in the Field), 1902, etching and drypoint on paper, 12 ⅝ × 9 ⅞ in., AG.1999.5.44.

Plate 26 (Fig. 11)
Paysanne en plaine (Peasant Girl in the Field), 1902, etching, drypoint, watercolor and gouache on paper, 13 ⅝ × 10 ¼ in., AG.1999.5.45.

Plate 27
Paysanne au crépuscule (Peasant Girl at Twilight), 1903, etching and drypoint on paper, 13 × 10 ¼ in., AG.1999.6.5.

Plate 28
Paysanne au crépuscule (Peasant Girl at Twilight), 1903, etching and drypoint with watercolor and gouache on paper, 13 ¾ × 10 ⅜ in., AG.1999.5.49.

Plate 29
Paysanne allant à la pêche (Peasant Girl Going Fishing), 1904, etching and drypoint on paper, 12 ⅞ × 10 ⅛ in., AG.1999.5.22.

Plate 30
Paysanne allant à la pêche (Peasant Girl Going Fishing), 1904, etching and drypoint with pencil, watercolor, and gouache on paper, 12 ⅞ × 10 ¼ in., AG.1999.5.20.

Plate 31
Paysanne brûlant des herbes au crépuscule (Peasant Girl Burning Grass at Twilight), 1900, pencil on paper, 13 × 17 ¾ in., AG.1999.7.8.

Plate 32
Paysanne brûlant des herbes au crépuscule (Peasant Girl Burning Grass at Twilight), c. 1904, etching, drypoint, and chine collé on paper, 14 ½ × 19 in., AG.1999.5.53.

Plate 33
Paysanne brûlant des herbes au crépuscule (Peasant Girl Burning Grass at Twilight), 1904, hand-colored etching and drypoint on paper, 14 × 19 in., AG.1999.5.55.

Plate 34
Paysanne brûlant des herbes au crépuscule (Peasant Girl Burning Grass at Twilight), 1904, etching and drypoint on paper, 13¾ × 10½ in., AG.1999.5.54.

Plate 35
Nocturne no. 1 (la perle) peuplier (Nocturne no. 1 (The Pearl) Poplar), 1903, etching and drypoint on paper, 8¾ × 6⅝ in., AG.1999.5.78.

Plate 36
Nocturne no. 1 (la perle) peuplier (Nocturne no. 1 (The Pearl) Poplar), 1903, etching and drypoint on paper, 12¾ × 10¼ in., AG.1999.5.77.

Plate 37
Nocturne no. 3, Effet de lune, Village de Recloses (Nocturne no. 3, Moonlight, Village of Recloses), 1910, etching and drypoint on paper, 13¼ × 10 in., AG.1999.5.74.

Plate 38
Croquis du frontispice pour l'album du vieil Évreux (Sketch of the Frontispiece for the Album of Old Évreux), 1906, pencil on paper, 11¼ × 8⅞ in., AG.1999.5.56.

Plate 39
La cathédrale Notre-Dame d'Évreux (Notre-Dame Cathedral, Évreux), 1905, etching and drypoint on paper, 10⅝ × 14 in., AG.1999.5.173.

Plate 40
La vieille tour de l'horloge à Évreux (The Old Clock Tower, Évreux), 1905, etching and drypoint on paper, 14 × 10⅞ in., AG.1999.5.57.

Plate 41
Deuxième vue, La vieille tour de l'horloge à Évreux (The Old Clock Tower, Évreux, Second View), 1908, etching and drypoint on paper, 11⅜ × 8⅛ in., AG.1999.5.63.

Plate 42
Bonneuil-sur-Marne, 1908, oil on canvas, 16 × 19¼ in., AG.1999.5.11.

Plate 43
Bonneuil-sur-Marne, 1908, oil on canvas, 16 × 19⅛ in., AG.1999.5.10.

Plate 44
Parisian Street Scene, c. 1912, pencil and watercolor on paper, 6½ × 3¼ in., AG.1999.5.254.

Plate 45
Arc de Triomphe at Dusk, c. 1912, watercolor on paper, 6½ × 6⅝ in., AG.1999.5.141.

Plate 46
Notre-Dame Cathedral, c. 1912, pencil on paper, 7⅜ × 5⅞ in., AG.1999.5.180.

Plate 47
La porte de l'Aval, Mirepoix (The Aval Gate, Mirepoix), 1918, watercolor on paper, 10⅛ × 12¼ in., AG.1999.5.137.

INDEX

Page numbers in *italics* indicate illustrations. All artworks are by Charvot unless otherwise stated